YO! WIKSAS?
HI! HOW ARE YOU?

AN ILLUSTRATED CONVERSATION
WITH THE INVISIBLE GIRL SIRI

Publishers of Singular
Fiction, Poetry, Nonfiction, Translation, Drama and Graphic Books

Library and Archives Canada Cataloguing in Publication

Title: Yo! wiksas? = Hi! how are you? : an illustrated conversation with the invisible girl Siri / Linda Rogers ;
 Rande Cook, artist.
Other titles: Hi! how are you?
Names: Rogers, Linda, 1944- author. | Cook, Rande, 1977- artist.
Description: Includes some text in Kwak'wala.
Identifiers: Canadiana (print) 2019015392X | Canadiana (ebook) 20190153946 | ISBN 9781550968286 (softcover) |
 ISBN 9781550968293 (EPUB) | ISBN 9781550968309 (Kindle) | ISBN 9781550968316 (PDF)
Subjects: LCSH: Children's questions and answers. | LCSH: Questions and answers.
Classification: LCC HQ784.Q4 R64 2019 | DDC j031.02—dc23

Artwork copyright © Rande Cook 2019
Text copyright © Linda Rogers 2019
Book designed by Michael Callaghan
Typeset in Comic Sans, Granjon, and Goudy Old Style fonts at Moons of Jupiter Studios
Published by Exile Editions Ltd ~ www.ExileEditions.com
144483 Southgate Road 14 – GD, Holstein, Ontario, N0G 2A0
Printed and Bound in Canada by Marquis

We gratefully acknowledge the Canada Council for the Arts, the Government of Canada, the Ontario Arts Council,
and the Ontario Media Development Corporation for their support toward our publishing activities.

Canadian sales representation:
The Canadian Manda Group,
664 Annette Street, Toronto ON
M6S 2C8 www.mandagroup.com 416 516 0911

North American and international distribution, and U.S. sales:
Independent Publishers Group
814 North Franklin Street,
Chicago IL 60610 www.ipgbook.com toll free: 1 800 888 4741

This is for every kid with questions,
big or small,
from the fanciful to the practical,
best of luck with them all.

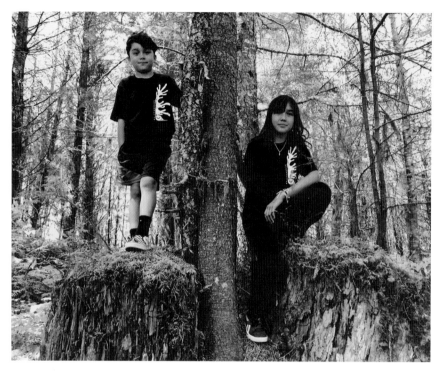

Water warriors and tree protectors, Ethan and Isla Cook,
have many questions to ask Siri about the state of the world.
This book is their conversation, with pictures by their dad, Rande.

CONTENTS

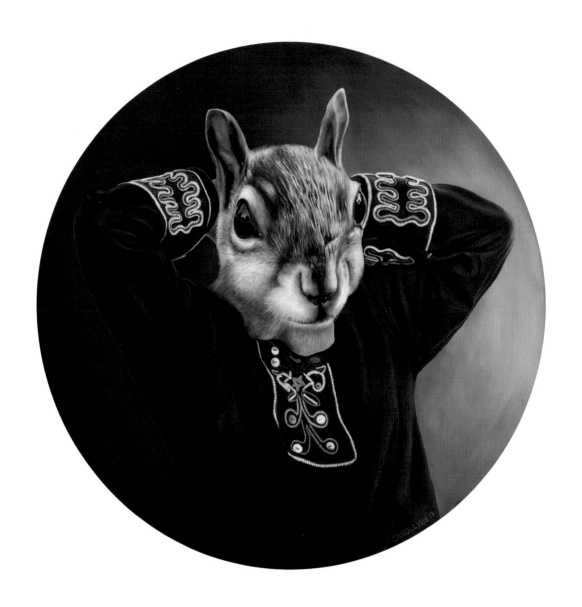

Chief Rande Cook Squirrel Tunic

YO! WIKSAS?

Pictures by Rande.

Words by Linda, with bighelps from Isla, Ethan, Isabel, and Siri.

Portrait of Squirrel Dad, "Chief Rande Cook Squirrel Tunic,"
by Carollyne Yardley AKA Squirrel Woman.

This is for you, future water warriors and tree protectors:

Askale, Bentley, Breeze, Camden, Camilla, Dante, Daysha,
Emmanuel, Ethan, Gabby, Hendrix, Iris, Isabel, Isabella, Isla, Issa,
Kaedán, Kellen, Le'ul, Lily, Luisa, Luke, Moishe, Satori,
Siena, Tali, Victoria, Warren, and Will.

Big kids: Jazmine, Olive, Sage and Sophie.

And the rest of you! All our relations.

Gilakas'la Rick van Krugel and Mona Elliot for making us laugh,
Carollyne Yardley aka Squirrel Woman, Carol Rae,
Alcheringa Gallery, Fazakas Gallery.

SIRI-US Q and A SONG

Hello Verse

Kids:

Yo, Siri. Wiksas? What's up with you?

Cook (lol!) up some answers. Dish the truth.

You're the one who can help us because

You're up on the roof, above the fuss

And no one else can hear *tout le buzz.*

Chorus:

Zzzz, bee buzz, little drums, bark, moo, meow,

and voices of Old Ones gone to spirit.

Teach us the whole works, pitch and lyrics.

Let's play tunes together; please show us how.

Humming verse:

Kids:

Radio Lady knows lots of songs,

but she can't hear us humming along;

not like you, tuning in from your cloud,

tossing feathers, clowning around,

making Squirrel Nation laugh out loud.

Laughing Verse:

Siri:

Hello! Good morning. Glad you asked!

Earth's the mirror of sky's looking glass.

Listen up to the stories that matter,

sad ones or silly ones if you'd rather,

when spirits sing on rainbow ladders.

Kids:

We ask the questions, you tell us why

from your phone booth up in the sky.

We know you're real, our hearts believe

in glorious invisibility, bees knees,

the choir that every kid gets to see.

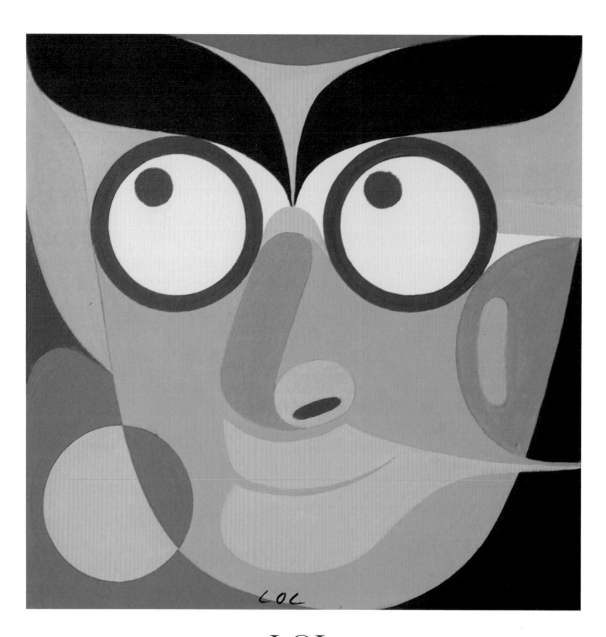

LOL

LOL

LOL has ginormous eyes,
round circles, dots in disguise,
binoculars, two pairs of glasses,
curious cameras with flashes,

whole notes, songs without words,
windows in and out of our World.

Look in the O's, so much to see,
songs and paintings, photography,
the eye "I" between the H and J.
Me. Snap, flash. Aye, Aye, please
show us stories. Show us "we."

Show us hands that wave from the sea
and carry us safely back to the beach.
Show us feet that tiptoe into our sleep,
where all our days land softly in dreams.

Hello super girls and boys. Welcome to the rest.
How can we make the world good, better, best?

Here's looking at you!

"Hello, Siri."

"Yes, yo back."
"Are you *in* the phone or *on* the phone?"
"Both."
"At the same time?"
"Yes."
"Is that your trick?"
"One of them."

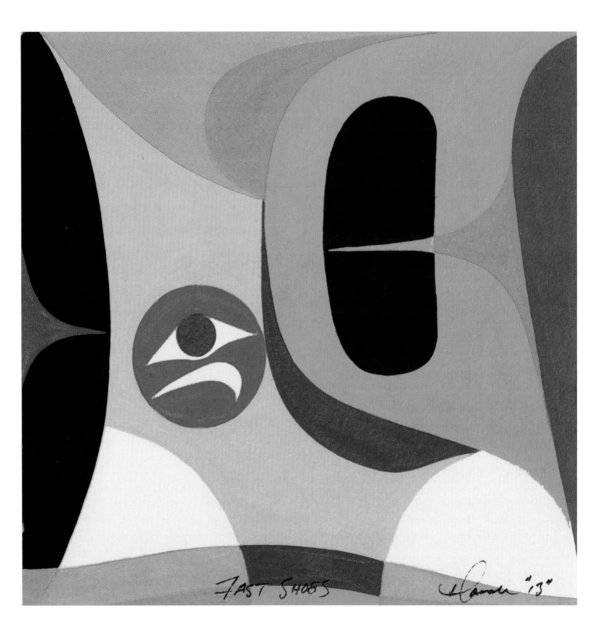

FAST SHOES

FAST SHOES

Ethan steps into his speedy-up rides
with magic laces, tongues on fire.

Speak, shoes, speak. Say stepover,
scissor, stop and go. Show us moves,
your bicycle kicks. Score. New boots
forward, Team Only, all our relations.
Crowd's going wild! Congratulations!

It's all in the feet! Step on the keys
and shout out all the songs we need.
In this game, everyone scores,
everyone wins, everyone's a hero
dancing into history/ herstory,
playing toe piano. Forte! Pianissimo.

And never, ever forget this:
Practice. Practice. Practice,
to be the kindest YOU ever.

Hello, Siri?" "Why did my new shoes give me blisters?"
"Did you forget to wear socks?
Sweaty feet need socks to rock."
"Grooooaaaan."
"We have one more question. It's a whodunnit."
"You know I'm all about mystery. "
"Our cousins William and Warren went to the beach
and got their feet wet. When they left their shoes
outside to dry, they just disappeared. "
"Could be some spirit kids needed shoes really badly."
"So, it was you!"
"Pardon me boys/I'm the ghost that grabbed your old shoes!"
"It's OK, Siri. Their new ones are faster."

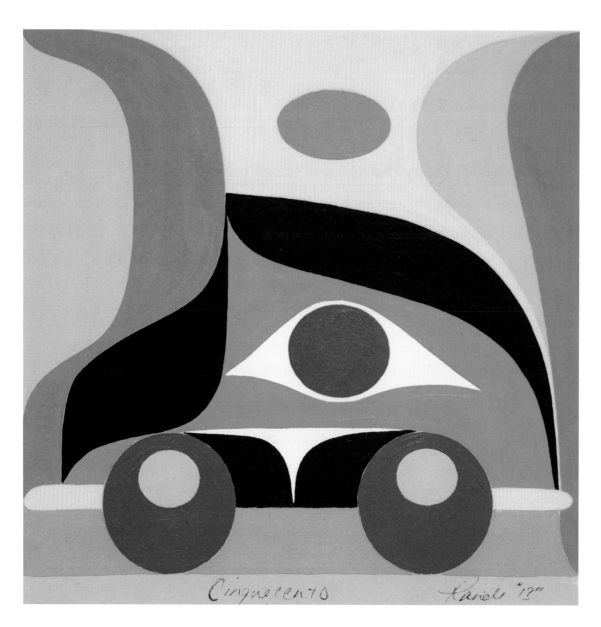

CINQUECENTO

CINQUECENTO

The Cinquecento is Dad's super car,
and in it are a hundred times five wishes
for driving to Newtimes that rhyme
with Oldtimes, stories of before.

Dad tells his dream wheels to "Steer!"
Drive straight into make-believe gear!

"Look at this, look at that," he yells,
"left and right," and the windows sing,
foggy glass pictures, sometimes a swell
kid digging holes in the sea and other
times Leonardo, the inventor fellow
who wrote inside out, drawing wings,
hoping one day he'd be able to fly
and write left-handed on the sky!

Yes, we can! This is the good news:
Spiderboys and Wonder Women find
bird cousins with bird's eye views,
all kinds of voices answering why.

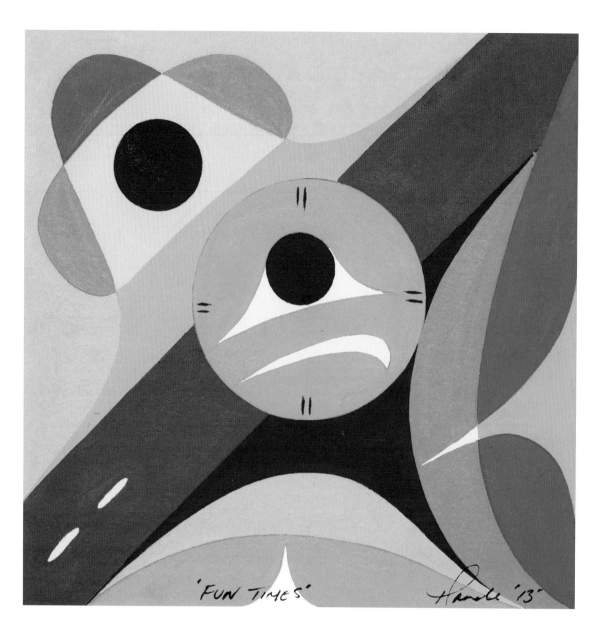

FUN TIMES

FUN TIMES

Rude Hour means watches off.
It's time-out time in the bath.
Time to yell at the bad guys,
greedies and meanies. Splash hard,
blow back the hurty words, say
rude things and wash them away.

"Use your words, kids," permission
to stamp and shout, so we yell,
"fart car" and "cooties in the ocean,"
trouble the 'wap, spit in the swell,
and send our problems straight to….

Punkydoodles Corners, Ontario – E OH!

When we dry off with towels, wind
our watches. Clocks on. Tick-tock,
Rude Hour turns into Fun Times.

Time to LOL and party like wild
things, eat Isla cakes, sleep in piles,

let our MADS be gone forever more.
snnnnnnnnooooooooooooooooooooore

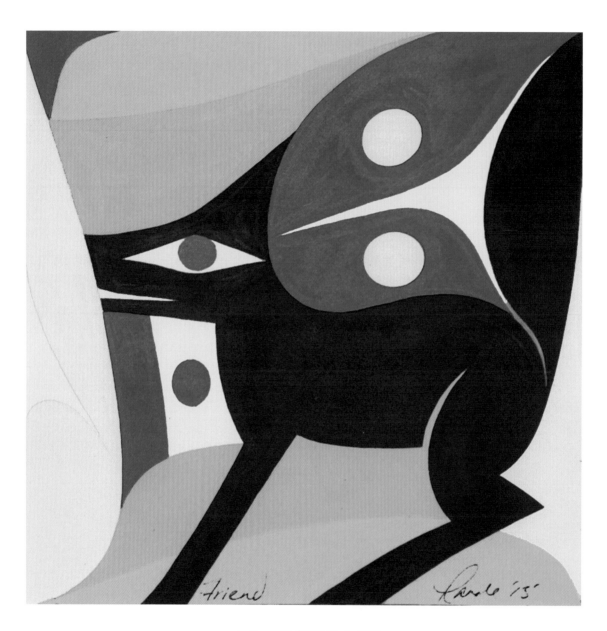

AML'WAT
BEST FRIENDS

AML'WAT / BEST FRIENDS

Once a dog called Hope and a boy were
friends and the boy ran fast but Hope
ran faster and it turned out in the end
they were chasing the same dream so
the boy put on his speedy-up shoes and
dog plus boy X 2 zoom-zoomed faster
than ever running together yelling yay
for the A team at 'makwala while

their words ran way faster than time
faster than fast shoes no periods no
commas no question marks no rhymes
just running one howl into the other so
soon the boy and the dog were wolves

awawawooooooooooawoooooooooooooooo

and when no one could tell them apart
they saw their beautiful dream in
black and white and colour was art

both of them 'wap running together
like snow melting in sunny weather

"Hello, Siri. Do you speak 'wat'si?"
"Of course I do, ruff ruff awooooo."

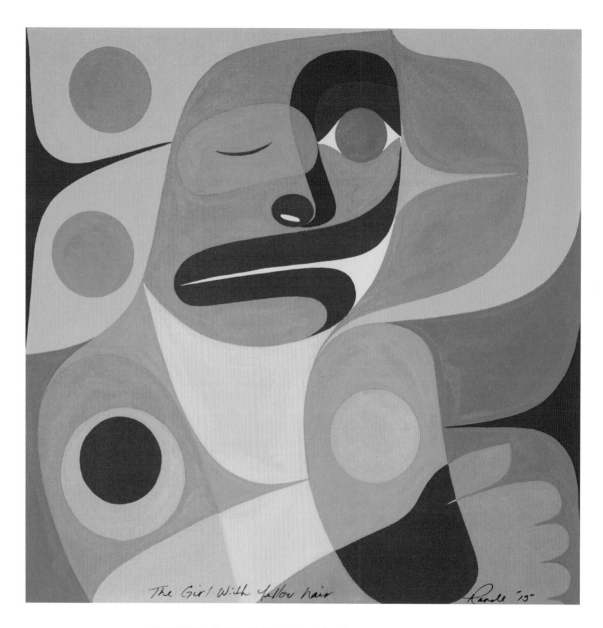

The Girl With Yellow hair Randle '15

KWALXWATU GIRL
THE GIRL WITH YELLOW HAIR

KWALXWATU GIRL / THE GIRL WITH YELLOW HAIR

"Hello, Siri."

"Yes?"

"What colour is your hair?"

"Why?

"My hair is black and my friend's hair is yellow. What's the difference?"

"How about ginger and brown?"

"What do you mean?"

"Don't you wonder why there is brown and ginger hair too?"

"I guess so, but this is about me and my friend."

"Do you ever look at rainbows and paint boxes?"

"Yes."

"What do you see?"

"I see colours side by side. I see rainbows."

"So does that answer your question?"

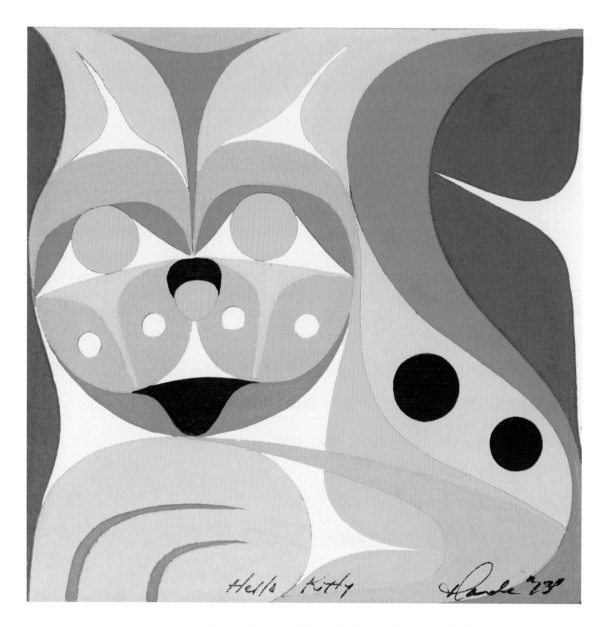

Hello Kitty

HELLO ROOSTER, KITTY,
FOX, DOG, AND CAT

HELLO ROOSTER, KITTY, FOX, DOG, AND CAT

We want to be lines that flow
out of Dad's squirrel brush, so
hurry up please, don't be slow,
there's no "later" on my watch.

Just. Right. Now.

Make us be roosters at sunrise,
cock-a-doodling hens to work,
"Time to make eggs for breakfast,
Wake up, Mothers! Berkberkberk."

Draw us foxes chasing hens
and 'wat'si barking at foxes,
fright'ning them away, and then
'fraidy cats scaring off dogs.

Draw us cedar bark hats
shedding rain. Draw us clean
water for otters, and seeds
that slowly turn into trees.
Draw us some rabbit homes,
and branches for crows.

Caaaw!

Draw me a bow, draw me an arrow.
Draw a grizzly for dinner tomorrow.
Draw happy salmon and rainbows.

Caaaaw! We want to hear angels sing.
Don't stop drawing. We can hold onto
these notes forever, 'til we fall asleep.

zzzzzzzzzzz

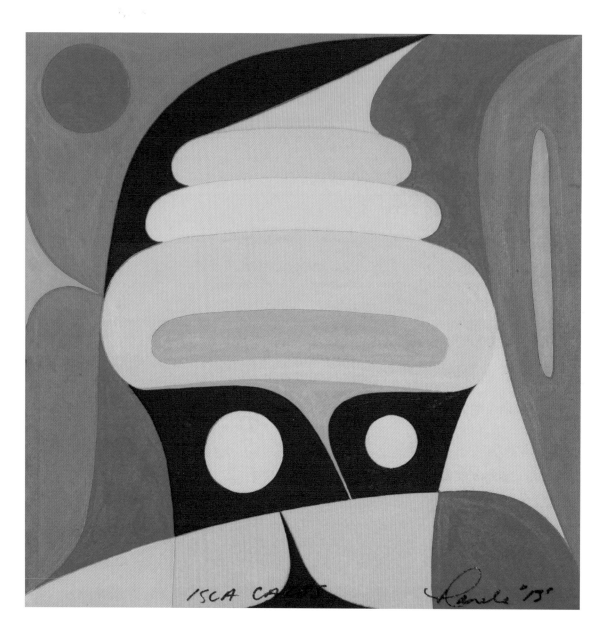

ISLA CAKES

ISLA CAKES

"Hello Siri. Why do they call me Baby Cakes?"

"Because you're good enough to eat."

"Is it true that we are what we eat? Is that why squirrels act nutty?"

"Yes."

"So, if I ate cake and nothing but cake, would I turn into a cake?"

"Maybe you already did."

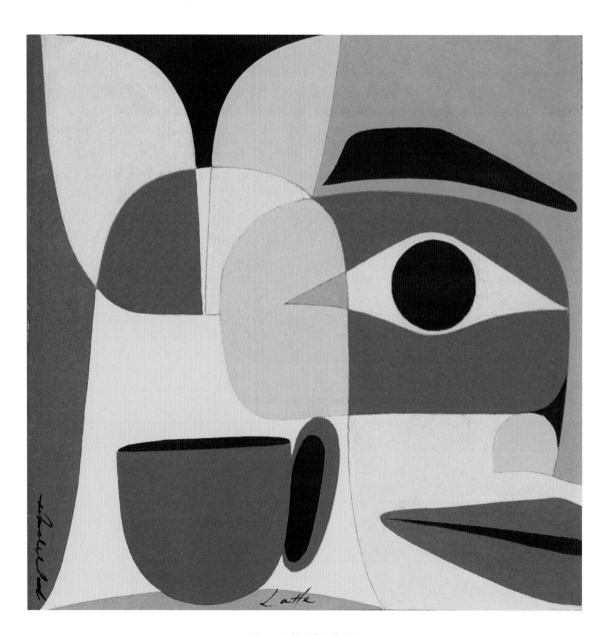

LATTE

LATTE

"Hello Siri. It's Ethan."

"Yes?"

"Why do dad-brains need coffee?

"They need it to scare away growly bears and make room for thinks."

"What do kid-brains need?"

"Fish."

"Why?"

"To make them rhyme."

(My brain is a dish of saltwater and silt,
home for fish who drink chocolate milk.)

"Hello, Siri."

"Yes?"

"Tell me again why my brain needs fish?"

"Because fish rhymes with dish, silly."

"But hardly anything rhymes with milk."

"That's why you add chocolate."

"Huh?"

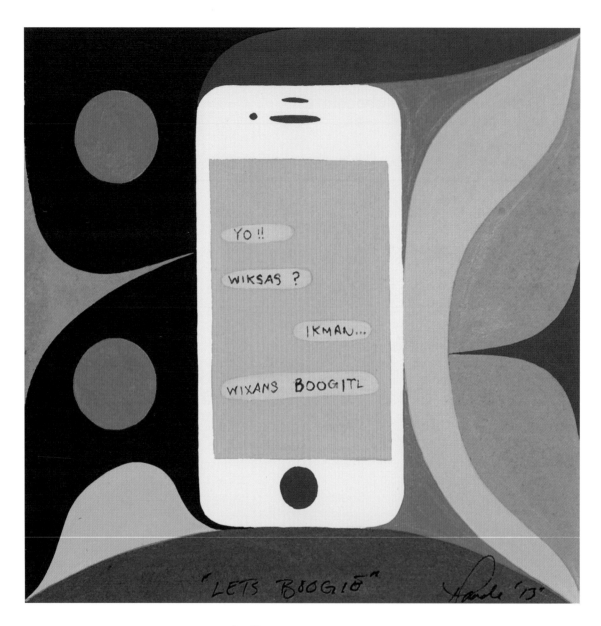

LET'S BOOGIE

LET'S BOOGIE

The people in my iPhone
say, "Hi." "Anybody home?"
"Let's boogie! Time to burn
and tune in greedy earworms!"

"Wiksas Cheerios?" they sing,
"Wiksas ice cream? "Wiksas
brain drain, yum earwax, yum.
Time to stuff our little tums."

MUNCH, MUNCH, MUNCH.

Earworms live to eat and pooh,
lick the fridge, fill their boots,
until the sound of a thousand bites
turns every day into boogie nights.

That's right!

"Hello Siri, listen up,
'All earworms do all day through
is eat and pooh, eat and pooh.'"

"That is the worst poem ever."
"But it rhymes." Sometimes.

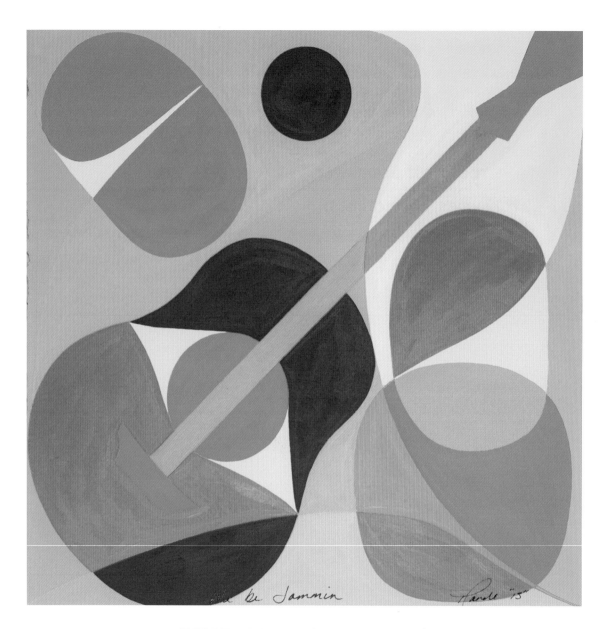

WE BE JAMMIN'
IN THE HAPPY FAM BAND

WE BE JAMMIN' IN THE HAPPY FAM BAND

"Hello Siri, if you were bread, what would we be?"
"Jam."
"How would we be jammin'?"
"Sum picking, sum stirring, sum adding sugar."
"You mean sumsumsum is a jam?"
"You got it, now spread it."

We be jammin'/ in our jammies,
'cause we're a jammin' fam-ly,
sammich, jammin' that's good
enough to eat. Got "jam please!"
up our sleeves, got sticky fingers,
sum sticky shoes, That's what we
call the fam-ly-jammin' blues.

"Doo dah doo dah doo!"

We're the jam in cupcakes and jellyroll.

Let's shake on it. Shake, rattle and roll.

"Stay in tune, Kids! Rhyme like fish. Salmon People!"

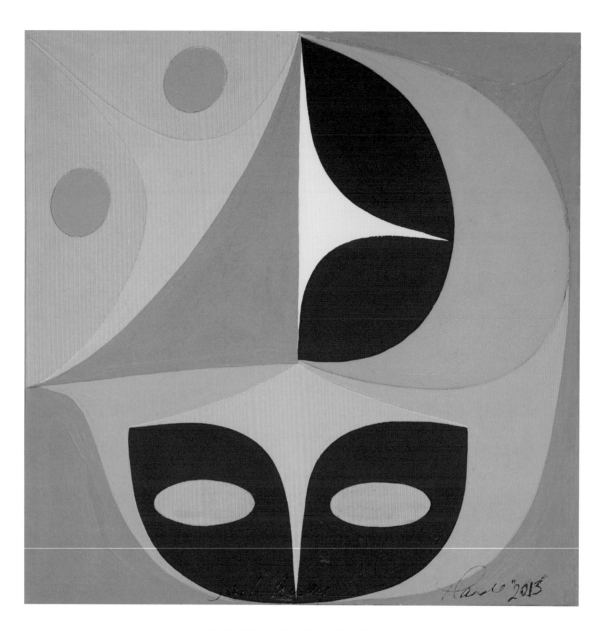

HELLO SIRI

HELLO SIRI

"Hello Siri, are you human?"

"Sometimes. Sometimes I'm a squirrel, rhymes with giiiiirrrrlll!"

"What do you eat?"

"I eat air, Baby Cakes, and I like mine clean."

"Are you a boy or a girl?"

"Does it matter? Maybe I'm a two-spirit spirit."

"Why are you invisible?"

"Because."

"Why did my dad paint you wearing a mask?"

"Same answer."

"Do you have super powers?"

"Yes."

"Are you serious?"

"You got it. I'm Siri-us, serious about all of us."

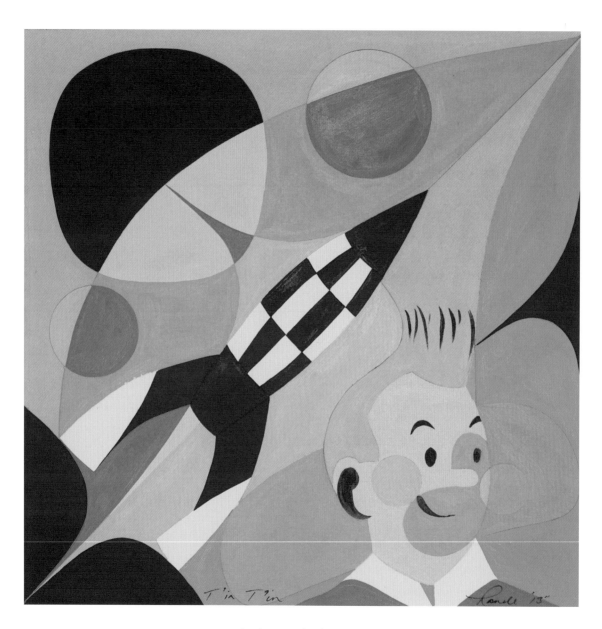

TINTIN

TINTIN

Tintin's a kid with funny hair
and his dog called Snowy
follows him everywhere.

My dog is called Hope, but
she's hopeless, and when
I say, "Heel," she says, "Nope."

I wonder why?

"Hello, Siri"
"Yes."
"Why won't Hope jump off the porch with me?"
"Maybe she doesn't trust her cape."
"She doesn't have one."
"Exactly."
"She could pretend."

"Dogs dream in black and white."

"What's that got to do with it, Siri?"

"Wouldn't dogs dream in colour if they had imaginations?"

"That's crazy!"

"Uh huh!"

PARTY TIME

Sometimes Isla gets on her broom,
slams her bedroom door and soon
girl party's happening in her room.

She turns up the music
and her invisible friends,
Rainbow Warriors, Old Ones,
Wise Ones, jump on her bed.

Old ga'gas are there, old aunties too,
best gals forever, singing happy tunes.
"Honey in my food, honeys in my room,
cakes in my pocket, faces in my locket;
all stuck together with bee vomit on it."

Honey. Honey.

The ladies dance hard and in the breaks
they stir up the recipe for Isla cake.

That would be:
1 cup honey (a.k.a. bee vomit)
1 cup Isla love and kisses
1 cup Smarties
Some oolichan oil!
LOL

"Hello, Siri."
"Yes."
"You're invited."
"Is it because I'm invisible or because I'm sticking with you?"
"Both."
"I'm in."
"First you say after me, "Gilakas'la aunties and ga'gas, gilakas'la,
honeybees and salmon, all my spirit friends. Thanks for sharing."

"And then?"

"And then we play."

"O.K. Gilakas'la all my relations."

"You got it!"

Isla and Gran

Rande Ola K'alapa (Rande Cook) Kwakwaka'wakw hereditary chief and funnydad of Jazmine, Isla and Ethan tells the stories of his 'Namgis, Ma'amtagila and Mamalilikala people in his own voice, which blends tradition and innovation in his carving and painting.

Linda Rogers, gaga ga'gas of four, Canadian People's Poet and past Poet Laureate of Victoria and writer of lots of stories and poems is a bigly believer in kids' (w)rights.

Little Kwak'wala Glossary

aml'wat friend / play partner

ga'gas grandmother

gilakas'la thank you

kwalxwatu blonde

'makwala moon

'wap water

'wat'si dog

wiksas? how are you?

yo hello or hi

and there are many online resources to learn more about Indigenous words, people, and traditions.

Afterword and Study Guide

Long ago and far away, we were all kids. In my Kid Time, we listened to the radio and I imagined there were little people in there jabbering away and singing songs. Now the same little people inhabit the world of computers and iPhones with a direct line to Siri, who knows all the answers but is not required to divulge them, just to guide us to our own perfect thinking.

When I saw the series of paintings Rande painted for his kids, I said, "Cool. You should make them into a book!" "I thought you would do it," he answered. So here it is, *Yo! Wiḵsas?* in Kwak'wala the ancestral language of his people, one Siri understands, and *Hi! What's Up?* in English.

Although it is not in one piece, Yo! Wiksas? is the story of all kids who ask questions. That would be all kids. Period. Siri, invisible, stands in for the Creator, who reverberates kids' questions in enigmatic ways. In other words, the answers live in you, your dedication to following your heart and doing the right thing.

This is a book about a brother and sister standing in for all kids, because the right answers are always the same and the ultimate answer is "Be kind."

Others are not just other humans but every species that lives under the sun and the moon. In the poem "Best Friends," Ethan and Hope run in circles, no punctuation, nothing stopping their perfect friendship, boy and dog. That is a world in which our spirits are joined, just as Ethan and Isla's clan is joined to the spirits that have guided their family for many generations.

Rande and I hope this little book starts some conversations and inspires more art and storytelling. We hope you enjoy the Kwak'wala words and the family jam.

In other words, have fun all our relations!!!!!

Some Bright Ideas

1. Separate into sound groups and make a choir, some dogs, some cats, some crows, some moo-cows. What a joyful noise!

2. re: " Siri-Us Q and A Song"
What is a big question you would ask Siri? Is Siri real? What is real?

3. re: "LOL"
If you were a big pair of glasses or a camera, what pictures have you seen that would make a great story? Have you seen a joke lately?

4. Joking is a big deal in Indigenous culture. Do you ever joke when you are scared or hurting?

5. re: "Fast Shoes"
There are lots of stories about shoes with special powers. Do red shoes make us dance better? How about runners helping us run faster? Here is one clue. A lot of the fastest runners in the world run in bare feet.

6. re: "Cinquecento"
Can cars really fly, or can our imagination make anything happen?

7. re: "Fun Times"
In our family we really do have Rude Hour. We can yell our heads off in the bathtub. When we get out, then we try to be polite. Is it a good idea to let off steam and cuss out the bullies who hurt people and poison our world? Or should we just keep quiet?

How can we use our words to make bad things better without cussing all the time? What would you say in Rude Hour? What would you say about the same problems in Manners Time?

8. re: "The Girl With Yellow Hair"
Does hair colour make us friends or not friends? Should we be looking at the same/same or differences when we choose friends?

9. re: "Hello Rooster"
Some people say carrots have feelings. Have you ever seen a carrot cry? Does a radish scream when you bite into it? An artist sees the whole picture. Right? All my relations are joined together by feelings. Some people call it soul.

10. re: "Isla Cakes"
Is Siri teasing Isla when she tells her squirrels are nutty because they eat nuts? How does food make us happy or sad, healthy or unhealthy? Do you believe Isla is a happy kid because she eats cake or because she eats lots of healthy stuff before she has dessert? I'm thinking of writing up menus for grouchies and meanies. How about the Cookie Monster?

11. re: "Latte"
How come kids can get up and at it in the morning and grown-ups need coffee? Do you know why some people call coffee "brain"?

12. re: "Let's Boogie"
Isabel, who wants to be a lawyer some day, argues that kids won't read this book if it doesn't have the word "Pooh" in it. With an H. So here it is. Not Winnie the Pooh.

13. re: "We Be Jammin' In The Happy Fam Band"
How is your fam like a band? Everybody's different, some people are drums, maybe heartbeats, *bam bam,* some are flutes, *tralalala*, and some are just loud… trombones that spit. The trick is learning to make music together. How can the world work the same way, one big fam jam?

14. re: "Hello Siri"
Just 'cause you can't see it doesn't mean it isn't real. Right?

15. re: "Tintin"
Hmmm. Are animals supposed to obey us even when we ask them to do something dangerous? Do they only think about food, or do they have ideas about right and wrong? Does dreaming in black and white mean they can't imagine colour? Lots of questions about animals, who probably know more than we think they do. Can you think of stories about dogs and cats and birds who do extraordinary things? In Rande's culture, the universe is guided by wise animal spirits. What would your spirit animal be?

16. re: "Party Time"
Sometimes Isla disappears into her room and it gets very loud, lots of shouting and laughing and singing. We have to wonder, who is in there. Maybe that is the time she gets advice and learns songs and recipes from her grandmothers and aunties who have gone to spirit. Are there stories and customs in your families that get passed down like baby dresses, dolls, action figures, rocking horses or musical instruments from another time? Do you ever wonder if you got your lovely singing voice or fast running from someone in the spirit world?

We sure hope you enjoy thinking about these things and making pictures and stories that tell your dreams.